Alton, Mono and Caledon Ontario in Colour Photos, Saving Our History One Photo at a Time

Photography
by Barbara Raué
updated 2019

Series Name:
Cruising Ontario

Book 47: Alton

Cover photo: Mansion on the hill, Alton, Page 25

©All the photos in this book have been taken with my cameras. I own the rights to them.

Series Name: Cruising Ontario
Saving Our History One Photo at a Time

Photos now in full colour
Check the Appendixes in the back of each book for descriptions of architectural terms and building styles

Book 33: Southampton
Book 34: Jarvis
Book 35: Hagersville
Book 37: Simcoe
Book 38: Cambridge Part 1 – Galt Book 1
Book 39: Cambridge Part 1 – Galt Book 2
Book 40: Cambridge Part 2 – Preston
Book 41: Cambridge Part 3 – Hespeler
Book 42: Kitchener Book 1
Book 43: Kitchener Book 2
Book 46: Shelburne
Book 47: Alton, Mono and Caledon
Book 224: Grafton, Bolton
Book 234: Belfountain, Inglewood
Book 235: Cheltenham, Terra Cotta

Table of Contents

Alton	Page 6
Caledon Village	Page 41
Mono Centre	Page 47
Architectural Terms	Page 49
Alton's Building Styles	Page 51

The County of Peel was created in 1805 following the purchase by the British Crown of the southern part of the Mississauga Tract on the shore of Lake Ontario. Surveyed in 1818-1819, the townships of Albion, Caledon and Chinguacousy were opened for settlement in 1820. Early settlements in the townships developed around water-powered mill sites on the Credit and Humber rivers, and at various crossroads. Development was influenced by the area's major landforms, including the Peel Plain, the Niagara Escarpment and the Oak Ridges Moraine.

The Town of Caledon was established on January 1, 1974 with an amalgamation of the townships of Albion, Caledon and the northern half of Chinguacousy. The primary administrative and commercial center of Caledon is the town of Bolton.

Smaller communities in the town of Caledon include Alton, Belfountain, Boston Mills, Caledon Village, Cheltenham, Inglewood, Mono Mills, Terra Cotta, and Victoria. The region is sparsely populated with farms.

Caledon is located northwest of Brampton. Caledon Village is located on Highway 10 at the center of the former Caledon Township. The village prospered with the arrival of the Toronto Grey and Bruce Railway in the early 1870s, linking Toronto to Owen Sound, with two trains passing through the village daily. By 1877, there were 350 people living in the area with three blacksmiths, a doctor, a tailor, two shoemakers, three hotels, two churches, a common school, the Orange Lodge, four driving sheds and three general stores.

Mono Centre is located in south-central Ontario north of Orangeville on Mono Centre Road (County Road 8). The Turnbull and Henry families settled here in 1823. The village included a general store, Mechanic's Library, hotel, blacksmith, grist mill, saw mill, wagon maker, church and township hall.

Alton is located 5 km south of Orangeville.

In 1816, Martin Middaugh Jr., a United Empire Loyalist, received a 200-acre grant of land. Middaugh started building a mill but died in 1827 from blood-poisoning caused by an axe wound. Elizabeth Middaugh Gaynor, Martin's widow, sold 50 acres to James McClellan, 50 acres to Nicholas Smith, and 100 acres to William McClellan who built a saw mill and a frame woollen mill along Shaw's Creek.

In the 1850s, George Dods started an axe and tool factory on the banks of Shaw's Creek. The Wright brothers built a grist/chopping mill. In 1854, a post office, named Alton Ontario opened with John S. Meek as the first postmaster; the village also took the name of Alton. By 1857, John Ford was operating a chair factory, and Robert Rayburn was running a tannery. In the 1860s, Blacksmith Edwin Rowcliffe and wagon-maker Samuel Boggs started making carriages. In the 1870s, Jameson and Carroll started quarrying limestone and built lime kilns east of Alton. James and Samuel Barber began producing open carriages and later make leather top models. Toronto Grey & Bruce Railway reached Alton in April 1871; Credit Valley Railway arrived in December 1879.

In 1881, Benjamin Ward and his son-in-law William Algie built stone mills along Shaw's Creek. A disastrous flood hit Alton in 1889 and the mill dams along Shaw's Creek were washed out. In 1904, cement sidewalks were installed on Queen and Main Streets; telephone service was established; John Deagle of the Cataract Electrical Company started wiring the village for electricity.

In 1914, Barber Bros carriage works building was converted for use as a shell and munitions factory during WW1. In 1935: Fredrick N. Stubbs and Sons, owners of 'Western Rubber Co.' converted Algie's mill to rubber production. In 1982, 'Western Rubber Company' factory closed, ending Alton's water-powered industrial history.

Alton

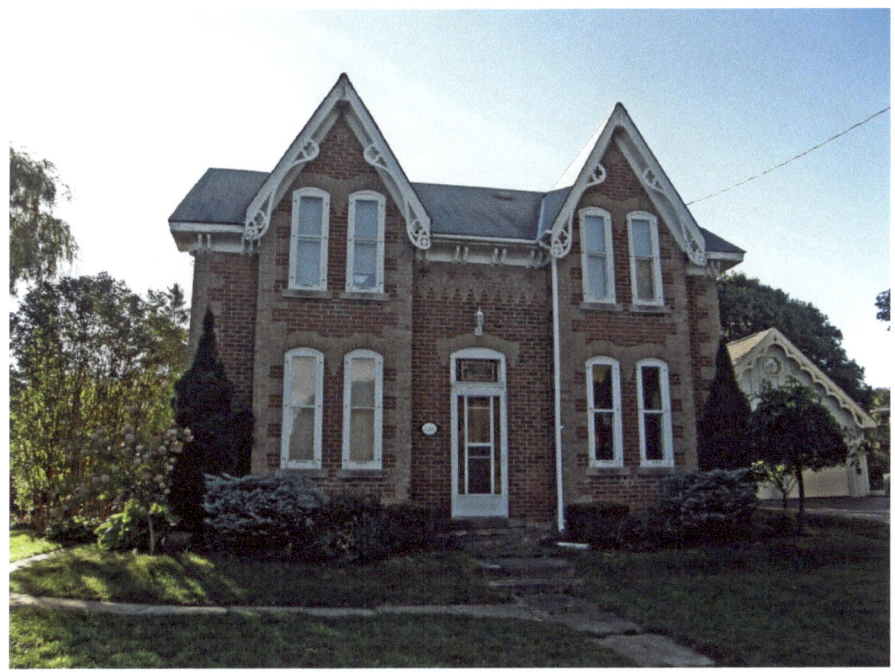

1581 Queen Street East - Archibald Dick House - circa 1875 - Hotelier Archibald Dick built this very elaborate Victorian Gothic style red brick house with contrasting yellow brick patterning, symmetrical projecting front bays, paired double windows, intricate fretwork and Italianate influenced paired brackets. The house has ten rooms.

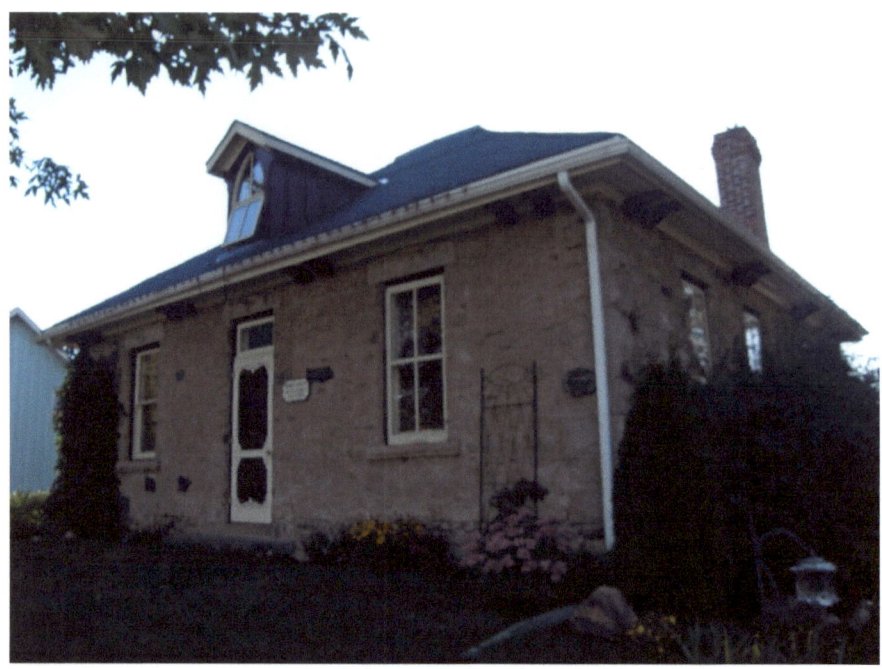

1565 Queen Street East - Stone Ontario Cottage - Thomas Wright, Merchant and Miller – built c. 1860s -This single storey, stone, Regency style cottage has a three-bay front façade with characteristic symmetrical design, paired brackets along the eaves, hip roof and an unusual Gothic style window in the dormer. The corners are local quarried stone, the lintels/sills are rock-faced sandstone while the walls are fieldstone parged with limestone mortar in an ashlar patterned finish.

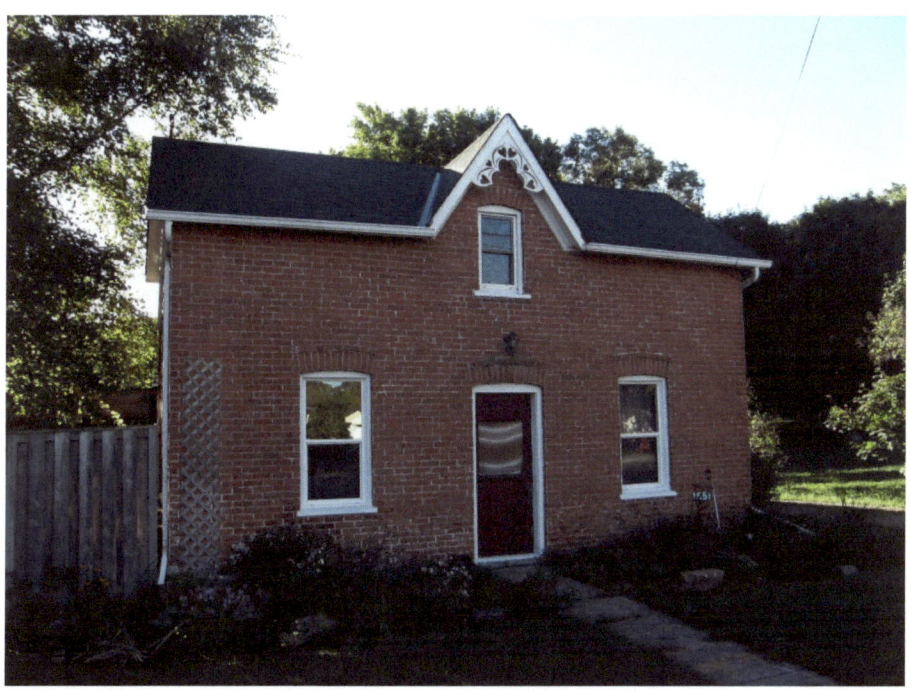

1551 Queen Street East - Ontario Cottage - circa 1881 - This 1½ storey Victorian Gothic style cottage is frame construction with a red brick veneer. Raised brickwork over the front door and windows along with gable fretwork add unique details to the façade.

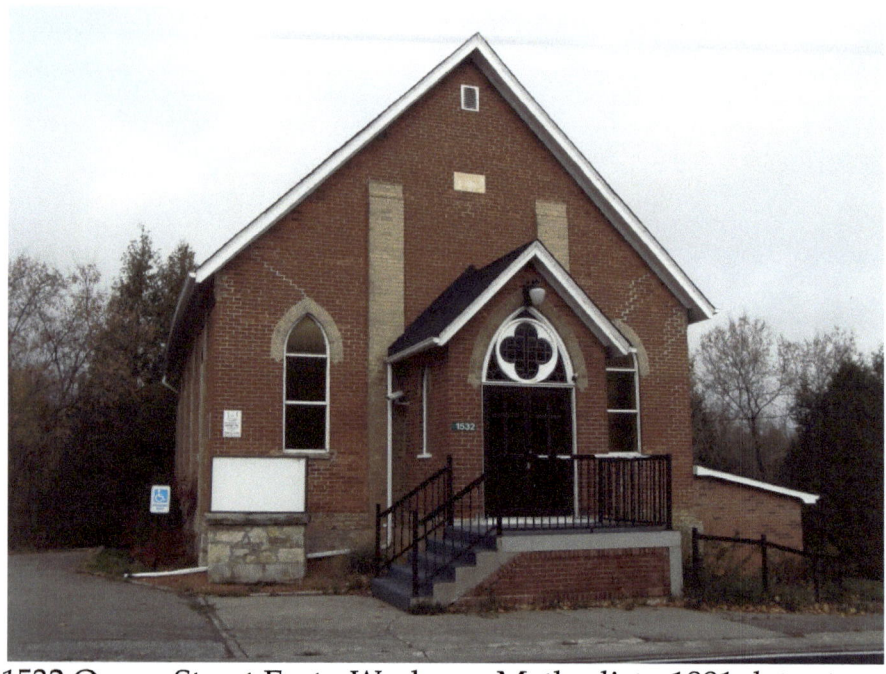

1532 Queen Street East - Wesleyan Methodist - 1891 date stone - This Victorian Gothic style church is clad in red brick with contrasting yellow brick details. There are Gothic style lancet windows on the front and side façades. In 1925, after church unification, it was re-named Alton United Church.

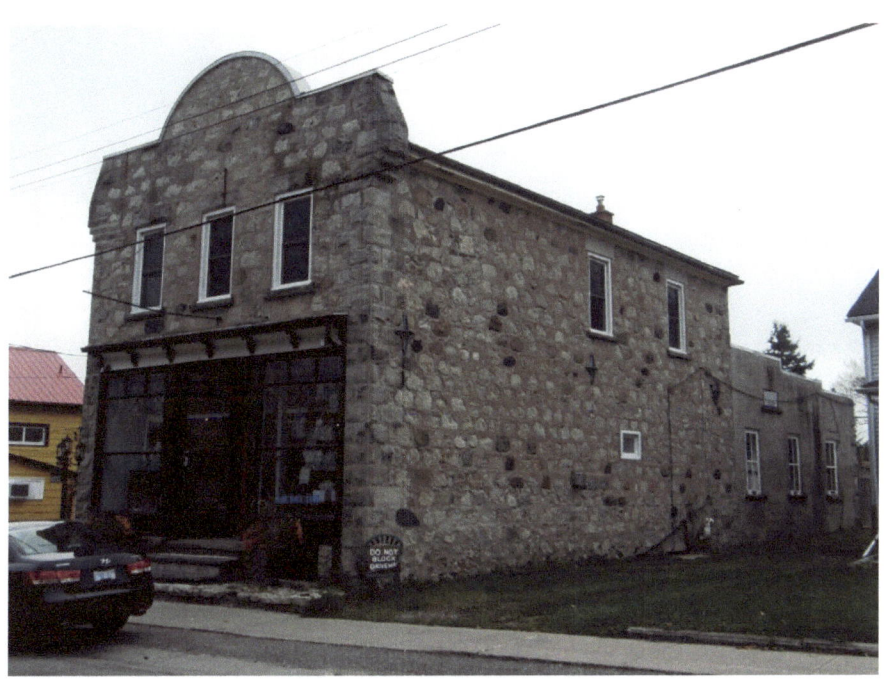

1469 Queen Street West - McCartney's Hardware - circa 1899 - This commercial building was built for hardware merchant Samuel Albert McCartney. The building was constructed using balloon framing with cut stone as the exterior cladding. Note the round shaped parapet, iron tie-rod plates on the side walls as well as the detailing on the original storefront. In 1903, McCartney sold the building to William White, a former harness maker and Alton's first magistrate. White opened a general store in the premises. In 1920, the building was sold to Alonze Tennyson who opened Tennyson's General Store. In 1923, James Hilliard converted the building to a barber shop.

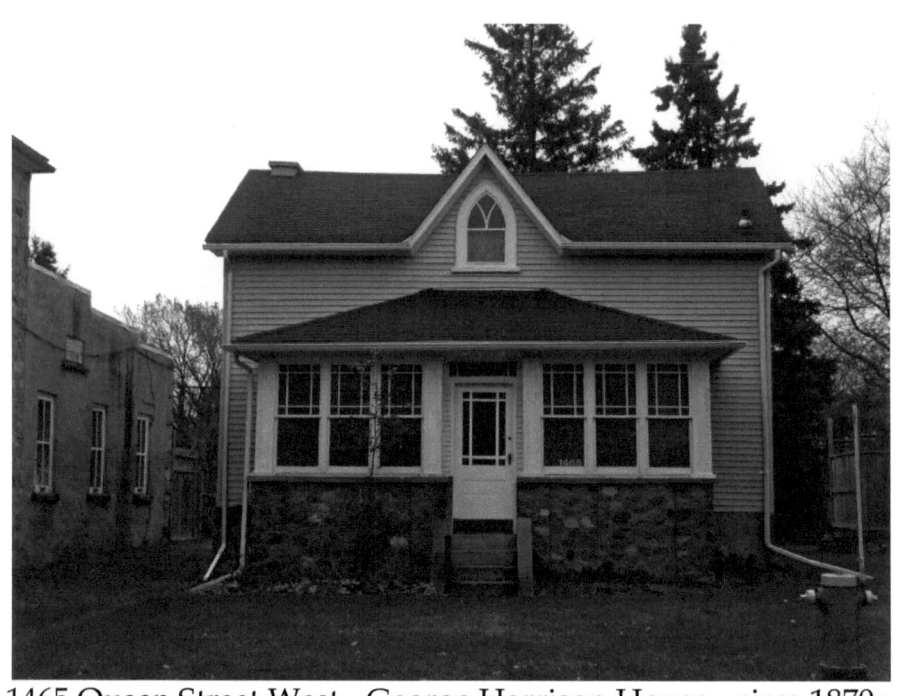

1465 Queen Street West - George Harrison House - circa 1870s - This 1½ storey frame Ontario Cottage is Victorian Gothic in style and its centre gable window has unusually fine tracery details. The house, built by George Harrison for his widowed mother Rachel Wilson Harrison and his sister Rachel, remained in their family until 1903 when it was sold to John M. Dods. Dods owned the stone mill property on the west side of Alton, now the Millcroft Inn and this cottage was likely used as housing for workers.

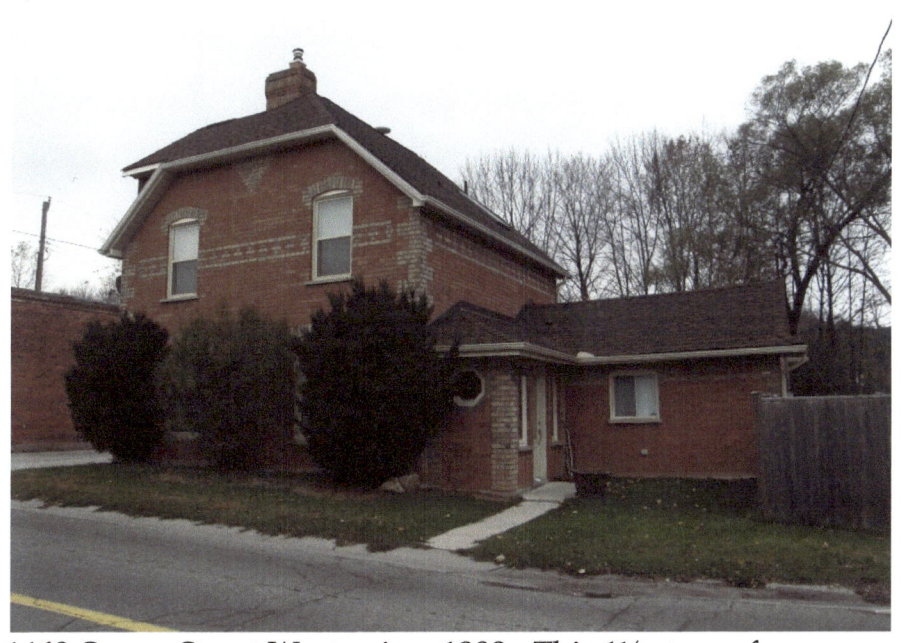

1460 Queen Street West - circa 1900 - This 1½ storey frame house with the 'clipped' centre gable end to the street has a west facing dormer window more typical of Edwardian Classical style. The house was built after the 1898 Alton fire insurance map was printed. The house has been clad with a modern brick veneer with contrasting brickwork trim made to resemble the Victorian Gothic style of the neighbouring Mechanics Institute.

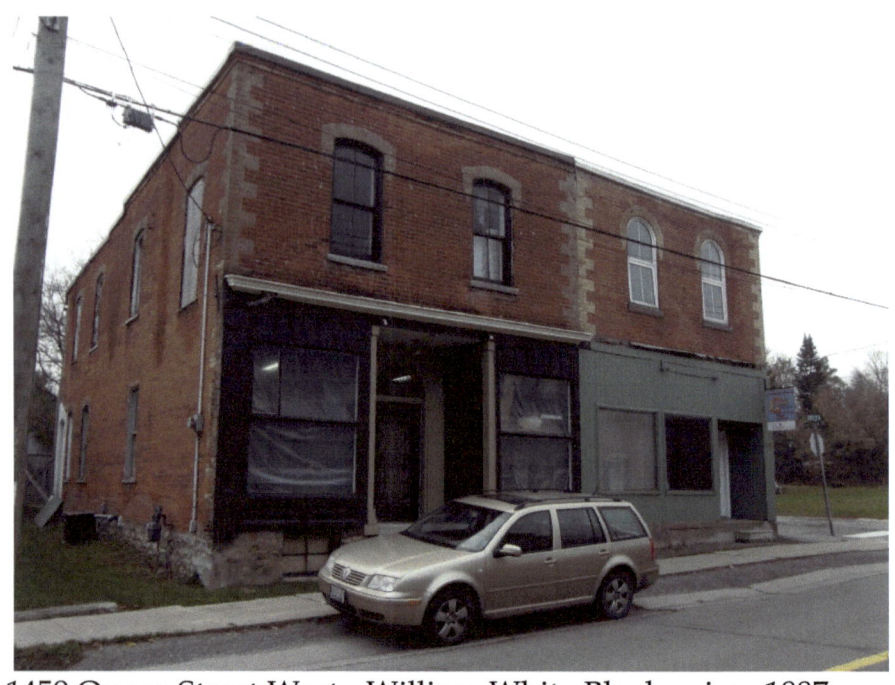

1459 Queen Street West - William White Block - circa 1887 - This double storefront, two-storey red brick commercial block is typical of late nineteenth century main street design. The individual units, each with their different architectural detailing, are defined by the use of yellow brick trim. The block was built by William White, a harness maker, and was purchased in 1889 by Dr. James Algie. The east half, was used primarily as a drug store and medical offices but is no longer in commercial use. The west half was primarily used as a general store including Algie's (Robert), Mason's, Chantler's and Cameron's.

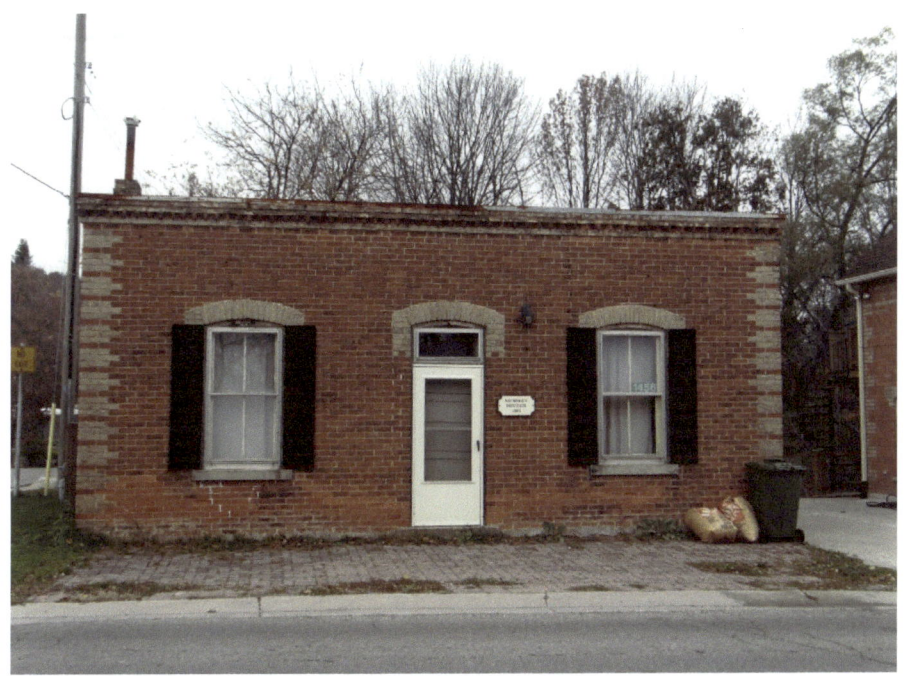

1456 Queen Street West - Mechanics Institute - circa 1882 - This single storey, three-bay frame building with red brick veneer cladding is the last remaining free-standing Mechanic's Institute in the Town of Caledon. Built on land provided by Robert Meek, mill owner William Algie, who served as its first president, financed construction. In 1888, the institute held almost 1,000 volumes and it operated for over 100 years until a new library opened on Station Street in 1992.

The first Mechanics Institute opened in Edinburgh, Scotland in 1821. Often funded by mill owners, institutes were created to provide education for an emerging group of skilled workers (mechanics) who built and maintained the equipment that powered the industrial revolution.

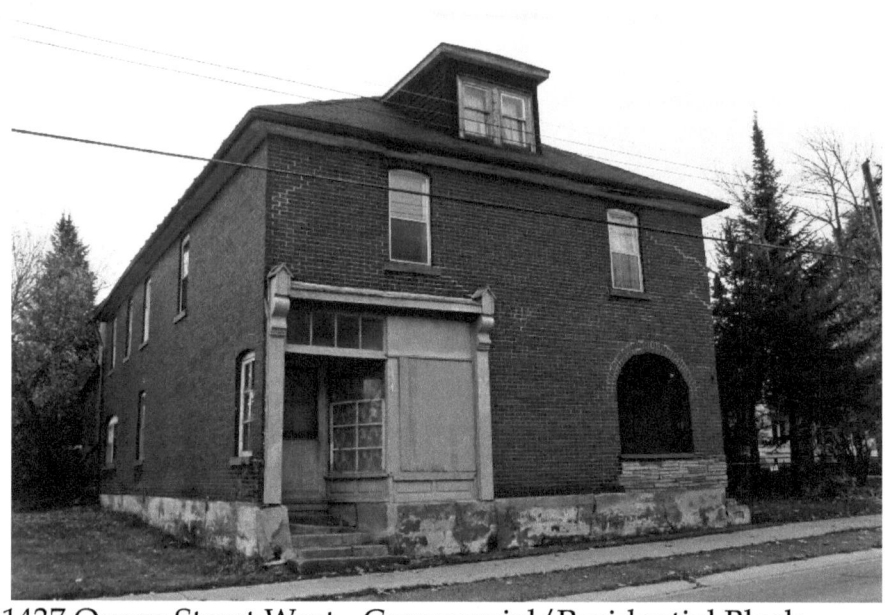

1437 Queen Street West - Commercial/Residential Block - 1870s - Originally a single-storey frame store and residence, by 1898 this building had acquired an upper level and a red brick veneer. Sometime after 1903, it was further enlarged with a full second storey, hip roof and front dormer in the Edwardian Classical style. The west half of the building remained residential; the ceiling above its entry is clad with stamped tin. The east half housed a succession of businesses starting with the McQuarrie Bakery followed by the Lake Bakery, Weeks Bakery, Oddfellow's Hall, and Broyden Bakery before being converted to its current residential use.

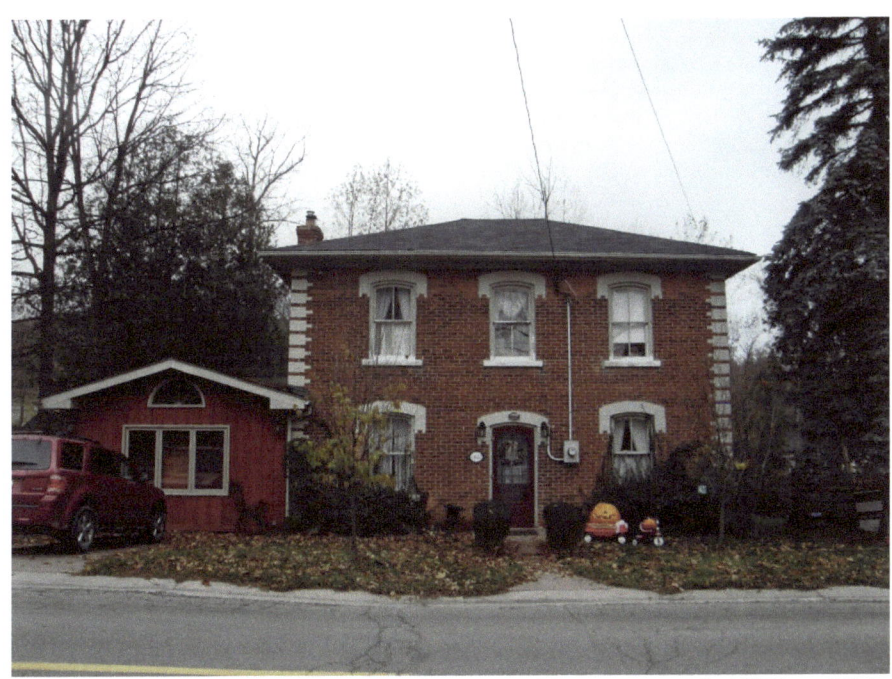

1422 Queen Street West - Dods-Long House - mid-1870s - This two-storey, Italianate style residence with red brick veneer and yellow brick detailing was built by foundry owner Alexander Dick during a period of considerable affluence in Alton. As Dick lived in an eleven-room house on Amelia Street, this beautiful home likely housed family members or employees. In 1908, retired woodworker William Dowswell purchased the house and lived here with his wife Christina and their three adult daughters. From 1916 until 1980 the property was owned by Madill family members.

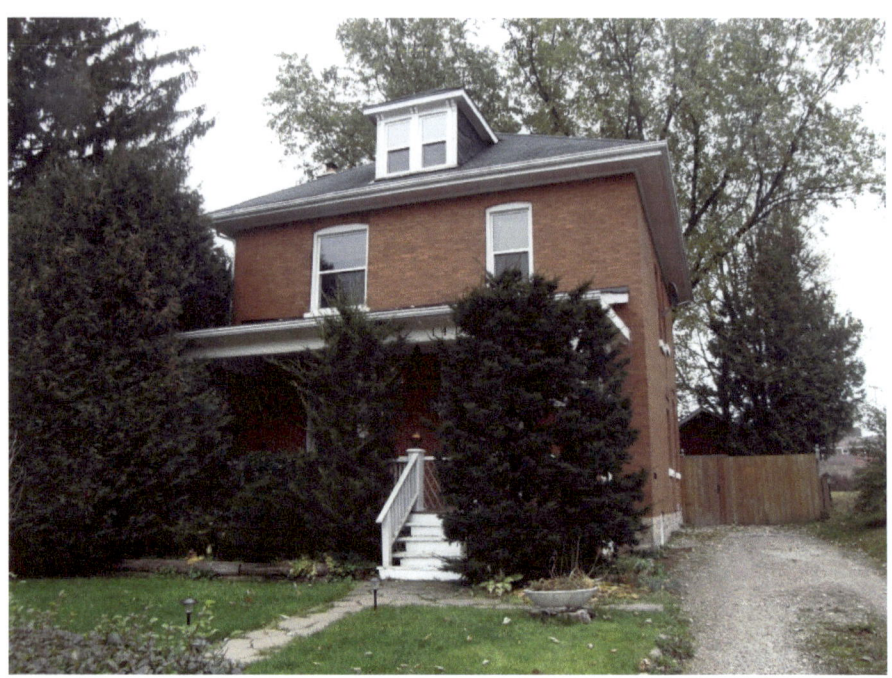

1417 Queen Street West - 'Four Square' House - circa 1905 - This two-storey red brick Edwardian Classical style house, built prior to James Algie's marriage to Sarah Dale, is a 'four square', with all sides equal in size. It has an asymmetric floor plan; the full width verandah with decorative brackets along its eaves is supported by classical columns on brick bases.

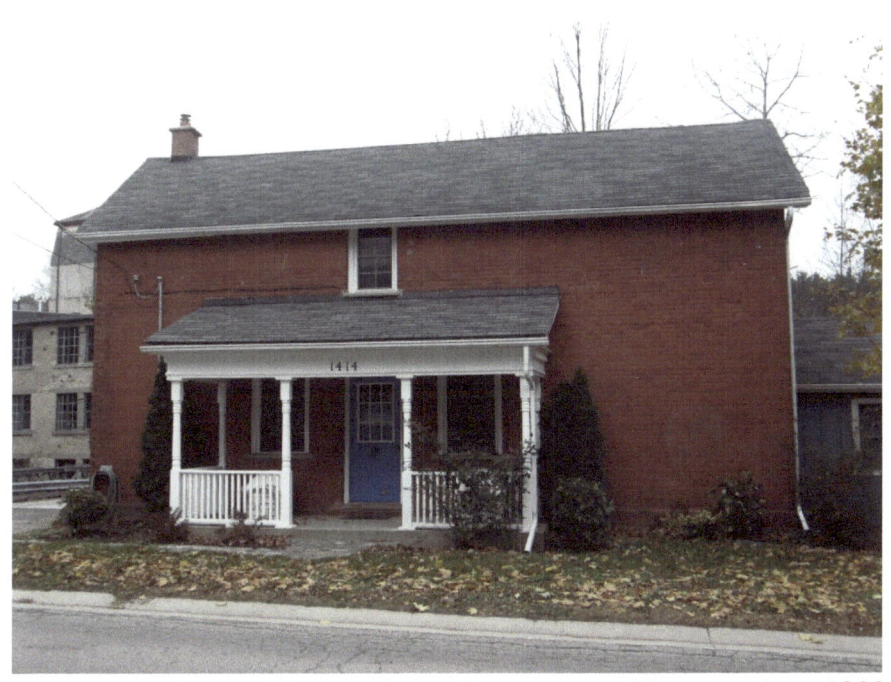

1414 Queen Street West - Nettie Dorrington House - circa 1899 - This 1½ storey late Neo-Classical style house was built by William Algie for his eldest daughter Janet shortly after her 1898 marriage to knitter, William A. Dorrington. The house is clad with very dense red bricks imported from the USA and has very unusual terra cotta hood moulds (drip moulds) over the gable end windows.

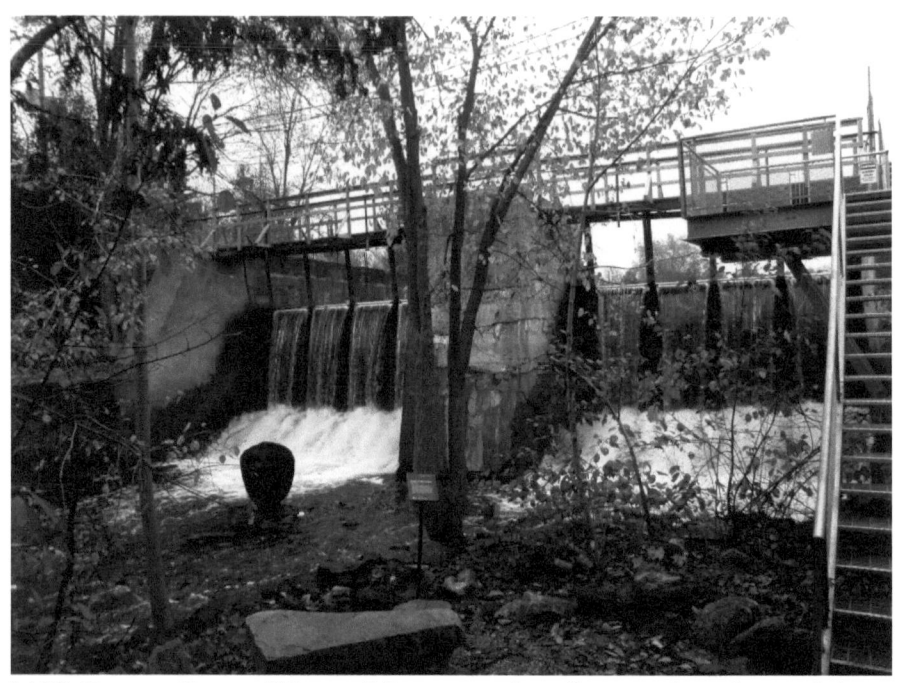

1402 Queen Street West - Now restricted to pedestrians, this bridge over Shaw's Creek was the original entrance into the woollen mill for wagons, carriages, carts and later automobiles. In 1857, Provincial Land Surveyor Charles Wheelock surveyed Shaw's Creek and identified nine mill privileges, eight of which were eventually developed. In October 1880, William Algie purchased mill privileges #5 and #6 from Kenneth Chisholm. Algie's mill and dam were built on #5, while the mill pond sits on #6. During the flood of 1889, Algie's dam held longer than others which allowed those living downstream time to reach safety.

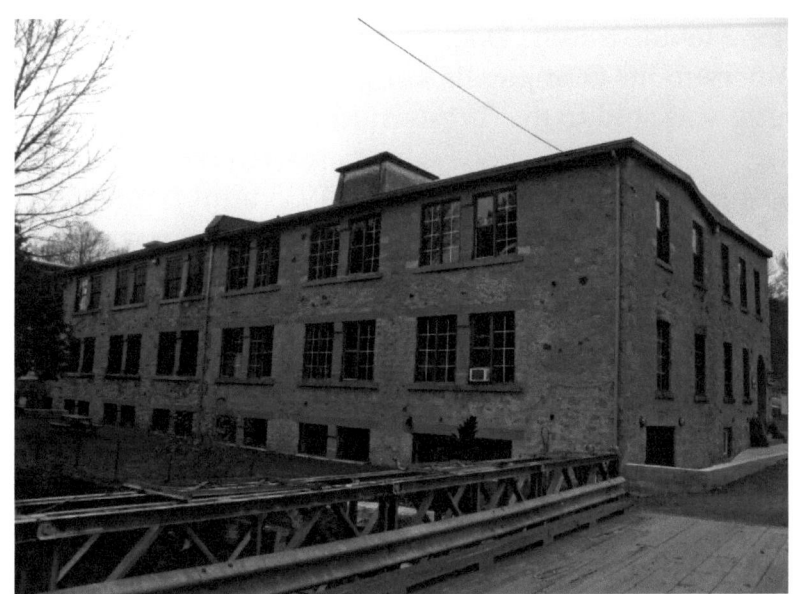

1402 Queen Street West - 'The Beaver Knitting Mill' - circa 1881 - This stone mill complex, constructed by William Algie was known nationwide for its fleece-lined long underwear. The mill complex was also referred to as the Algie Woolen Mill or the Lower Mill. The mill was enlarged twice, sustained massive damage in the disastrous 1889 flood and later survived a 1905 fire which reduced the original three-and-a-half limestone building to its present two storeys. By 1908, sixty employees worked as reelers, twisters, carders, spinners, knitters, dyers, etc. A 1913 addition is commemorated with a date stone on the east side by the pedestrian entrance. After William Algie's death in 1914, the mill was acquired by his brother-in-law, John M. Dods.

By 1932, in the midst of the depression and faced with changing textile trends, Dods closed the mill and moved the machinery to his Orangeville knitting mill. In 1935, the property was sold to the 'Western Rubber Co.' owned by Fredrick N. Stubbs and Sons who converted the mill for rubber production. It operated from 1935 until 1982 manufacturing items ranging from WW2 government contracted condoms and latex gloves to balloons for Disney. It was the longest-running water-powered mill on the Upper Credit River system.

The Alton Mill is now home to 30 studio artists, galleries, a heritage museum, café and unique shops.

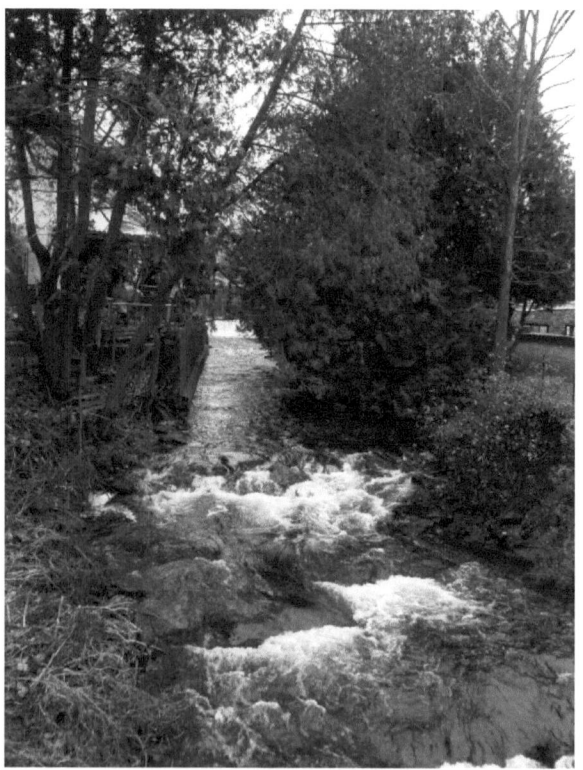

Shaw's Creek

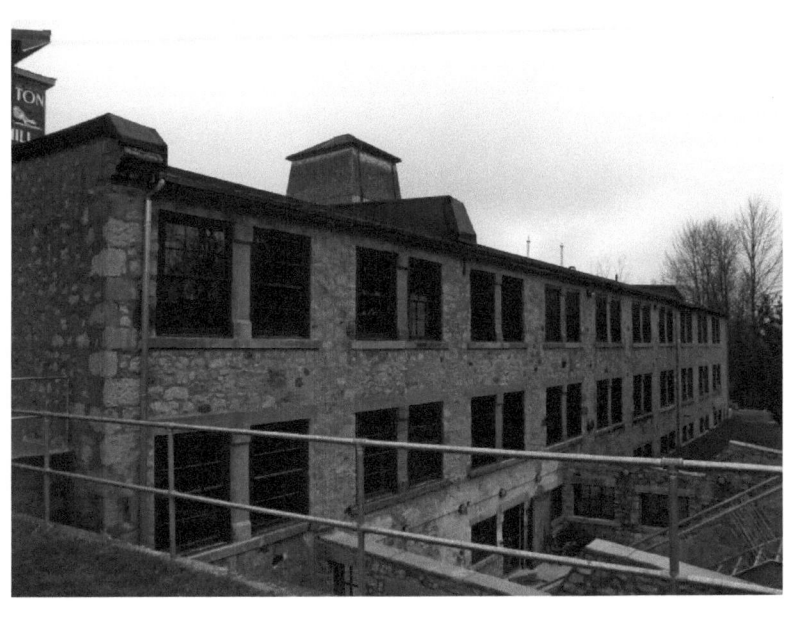

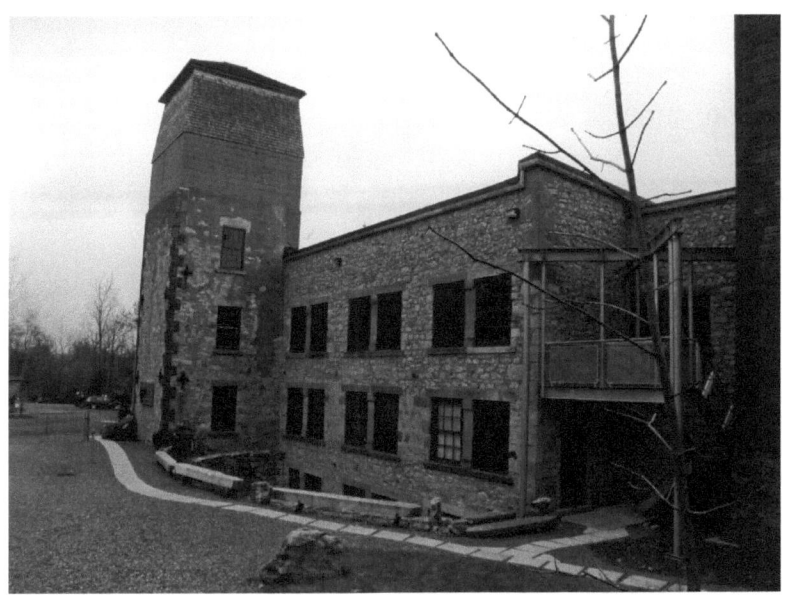

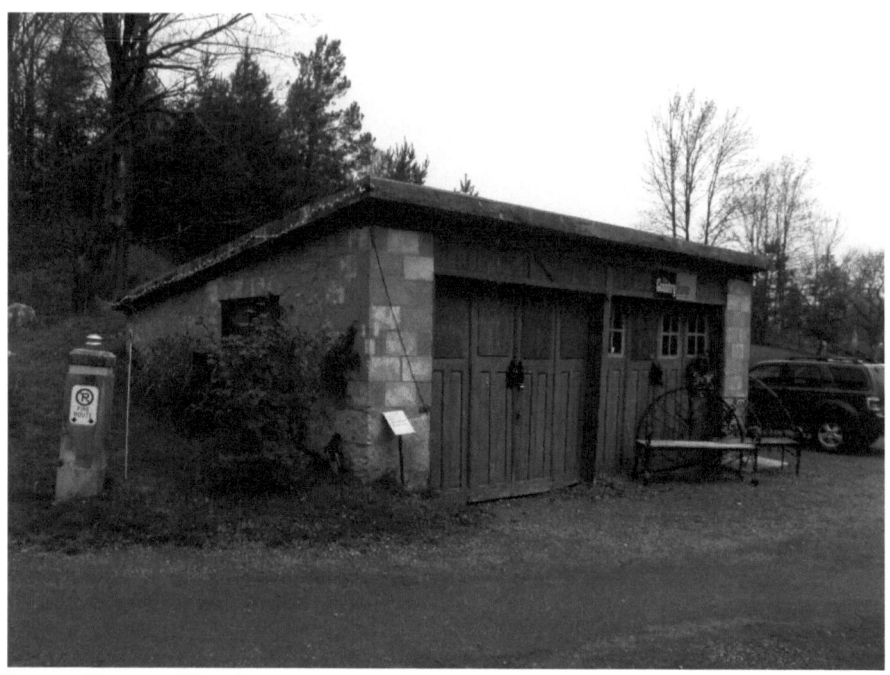

Stone Drive Shed - circa 1880s - This stone garage is built into the base of the hill and sits opposite the mill entrance and bridge across Shaw's Creek. It was likely originally used as a drive shed or livery. 'The Country Forge' now occupies the building.

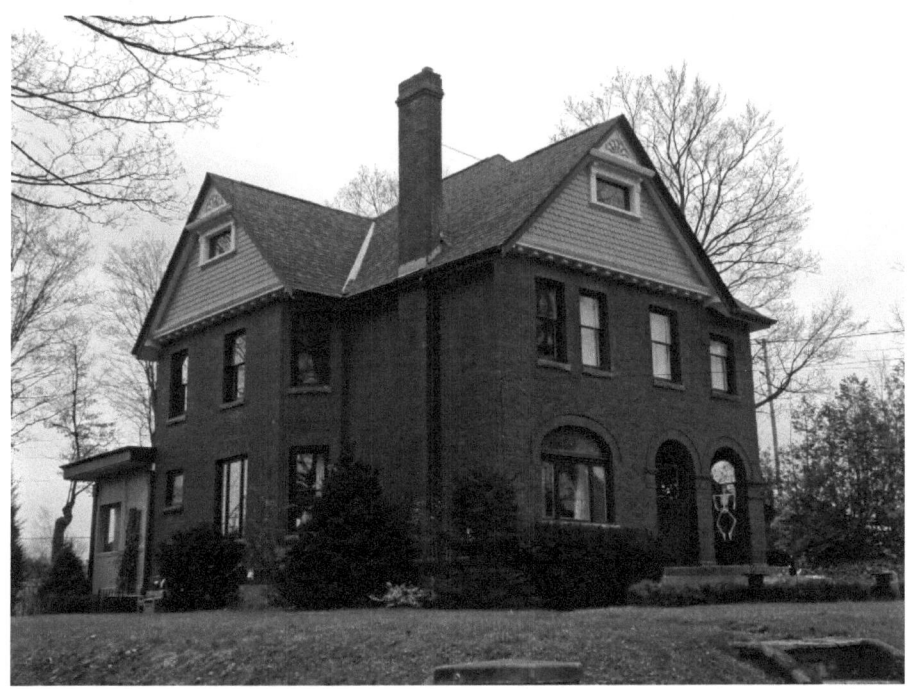

1401 Queen Street West - Romanesque Style - circa 1899 - This house, built for members of the Algie family, is clad in the same imported red brick as that used at #1414 across the street. The house has a double arched entry with intricate brickwork detailing and terra cotta hood (or drip) moulds above the entry and windows; three symmetrical and identical roof gables face north, east and west. Dr. James Algie lived here and kept a horse and buggy in the carriage house to the rear for visiting patients.

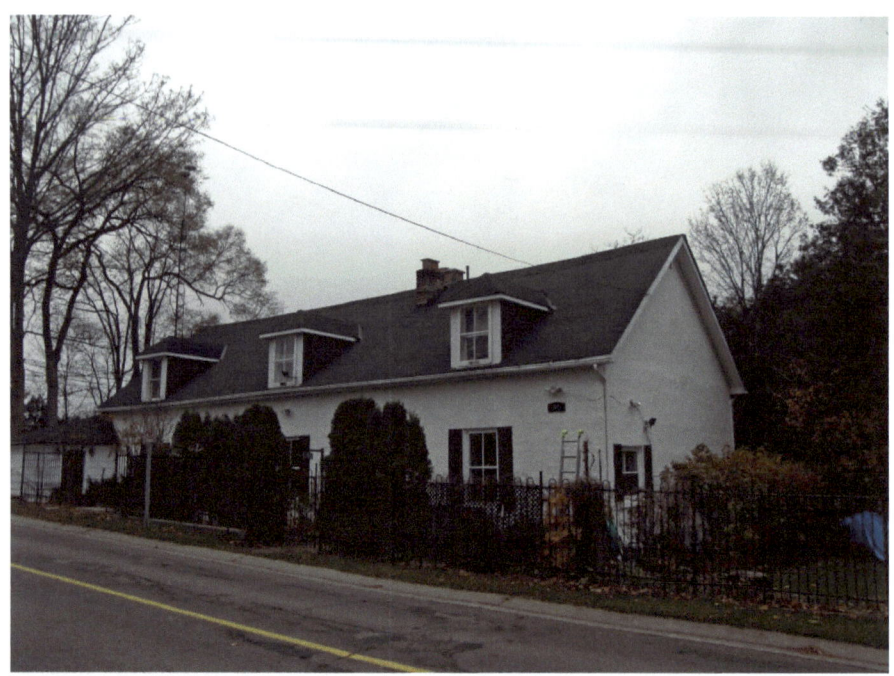

1398 Queen Street West - Science Hall - circa 1885 - This stone building is late Neo-Classical in style with a parged limestone finish. Known as Science Hall, it was built by mill owner William Algie as a community venue for lectures, concerts, plays and recitals. Algie was a 'Free Thinker' who believed that science together with knowledge and books provided life's answers, rather than religious dogma. He frequently invited lecture guests from Europe and the USA and supported a full orchestra as well as a citizen's band. The hall also housed the Alton drama club organized by Algie's brother Robert, a local merchant. After William Algie's death in 1914, the hall was sold to 'Dods Knitting Co.' and by the 1930s, had been converted into three apartments occupied by the Nicols, the Browns and the Woods. The latter started Woods Bakery in their unit.

Town Crier opening the Hockey Tournament
February 9, 2013

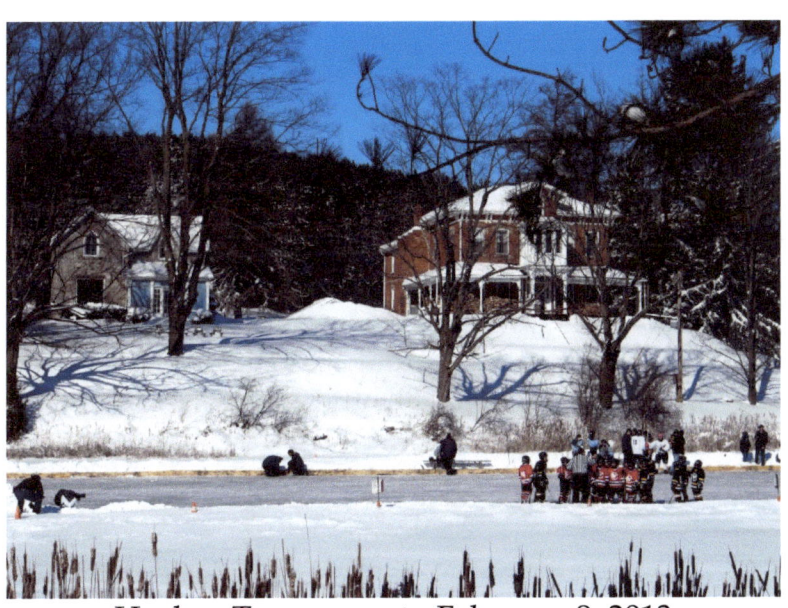

Hockey Tournament - February 9, 2013

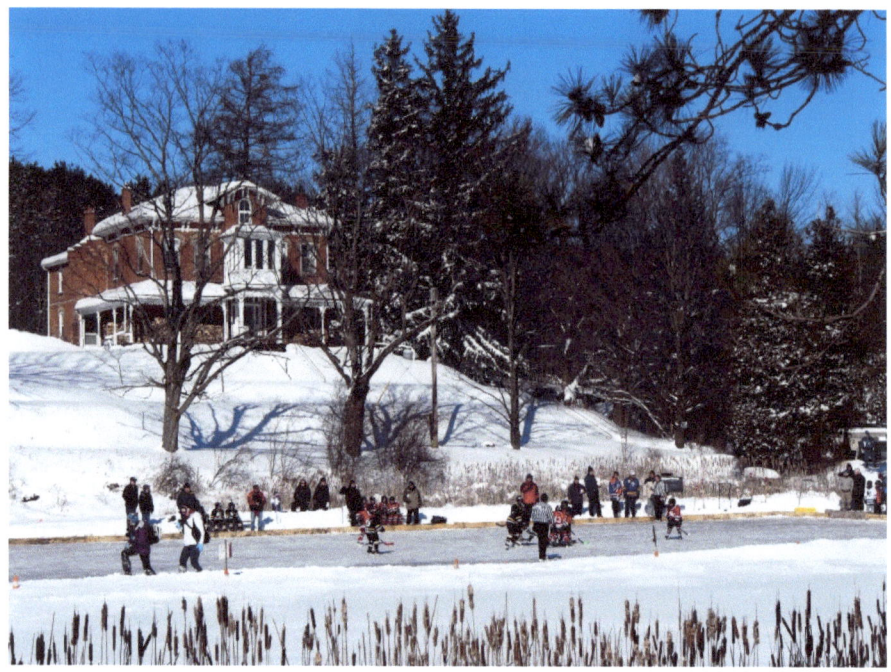
Mansion on the hill

1386 Queen Street West - William Algie House - circa 1881 - Situated with a commanding presence above the lower mill pond, this very large two-storey red brick Italianate style home was built for 'Beaver Knitting Mill' owner William Algie and his wife Phebe Ward. The house is symmetrical with decorative paired brackets around the eaves and a projecting front bay, which extends into an attic dormer through the hip roof over the ornate covered entry. A beautifully detailed porch encircles three sides of the home. Village garden parties were frequently held on its expansive lawns.

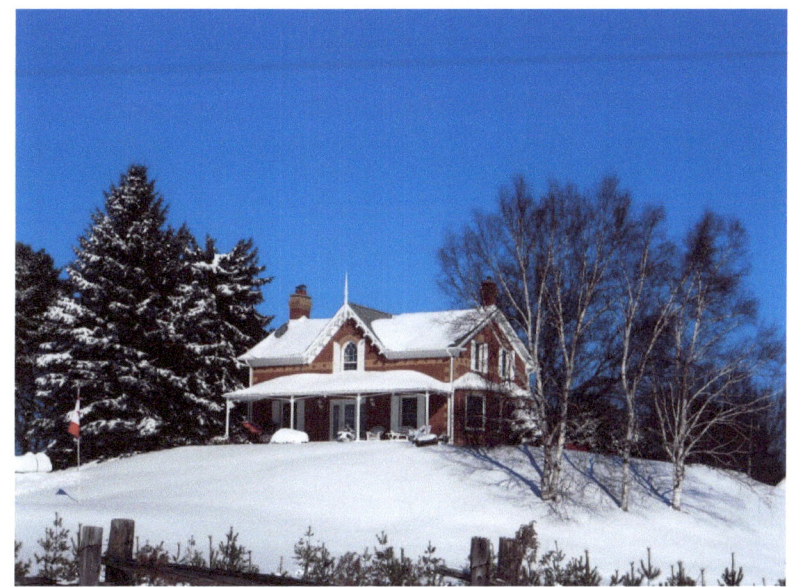

Gothic Revival – verge board trim and finial on gable, dichromatic banding

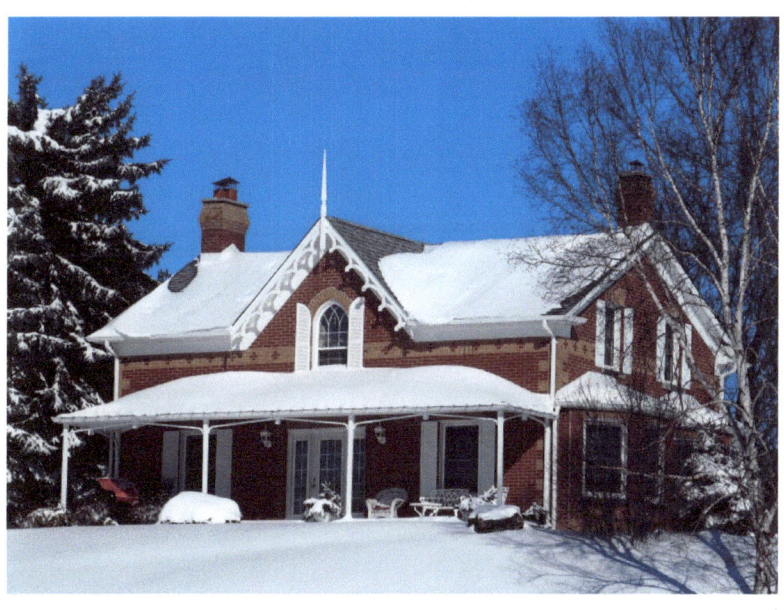

1380 Queen Street West - Algie Family House - circa 1881 - Overlooking the lower mill pond, this 1½ storey Victorian Gothic style stone residence with its steep gable roof was constructed at the same time as the original mill. It used coursed local limestone quarried east of Alton; its modern rear addition is clad in board and batten. It appears that until the early 1900s, this was the home of William Algie's parents Matthew A. and Janet Algie as well as their daughter Agnes and later their married daughter Elizabeth Thurson.

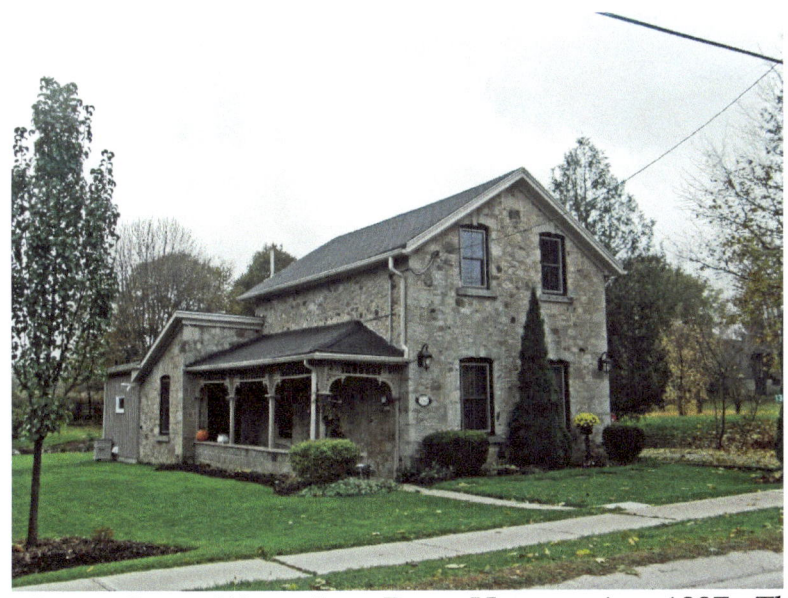

1341 Queen Street West - Jane Berry House - circa 1887 - This 1½ storey Victorian Gothic stone cottage was built for Jane Berry who later married Arthur Walker. The fieldstone exterior is parged with limestone mortar in an ashlar finish replicating quarried stone. Note the decorative verandah trim, elongated window keystones and limestone window arches, sills and quoins. After the shed-roofed fieldstone rear wing was built, the original front door was converted into a window. In 1897, the Walkers sold the house to Margaret M. McDougall.

1302 Queen Street West - Worker's Cottage - pre-1867 - Originally built as a 1½ storey Neo-Classical style Ontario Cottage, new roof lines and exterior cladding have dramatically altered this mid-19th century home. The house was sold to Walter McClellan in 1867 presumably to house mill workers.

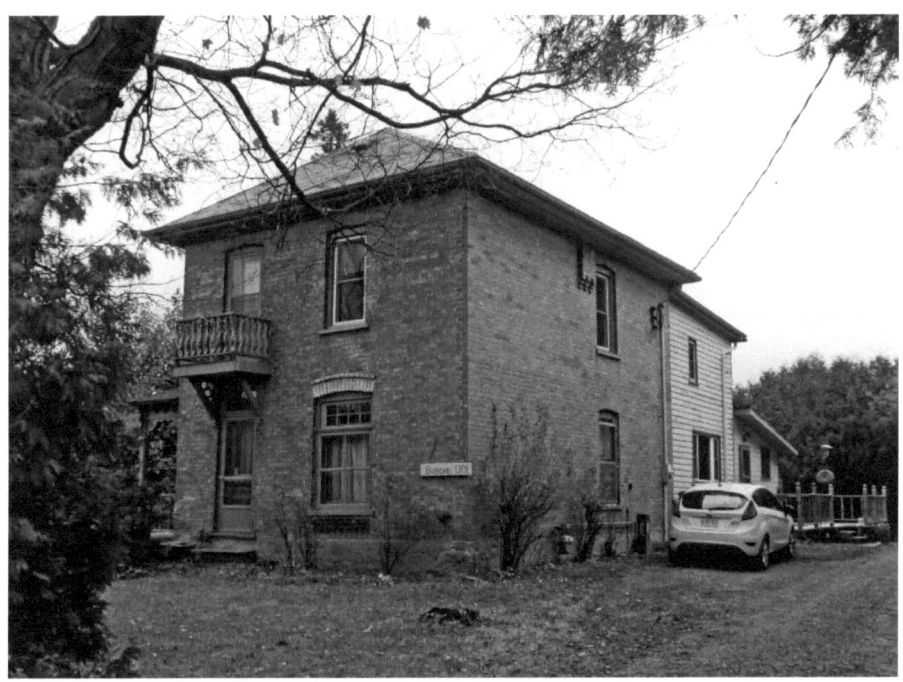

1301 Queen Street West - Italianate Style - circa 1885 - This L-shaped two-storey house was built for mill owner Benjamin Ward. It is Alton's only yellow brick house and has an asymmetric floor plan, separate side entrance, decorative brickwork under the main floor windows, bracketed fretwork and coloured glass in the transom and main floor window lights. By 1901, the house was owned by John M. Dods' niece Jeannette Dods and her husband John Erskine, a mill worker. Their son Everton inherited the property living here until 1951.

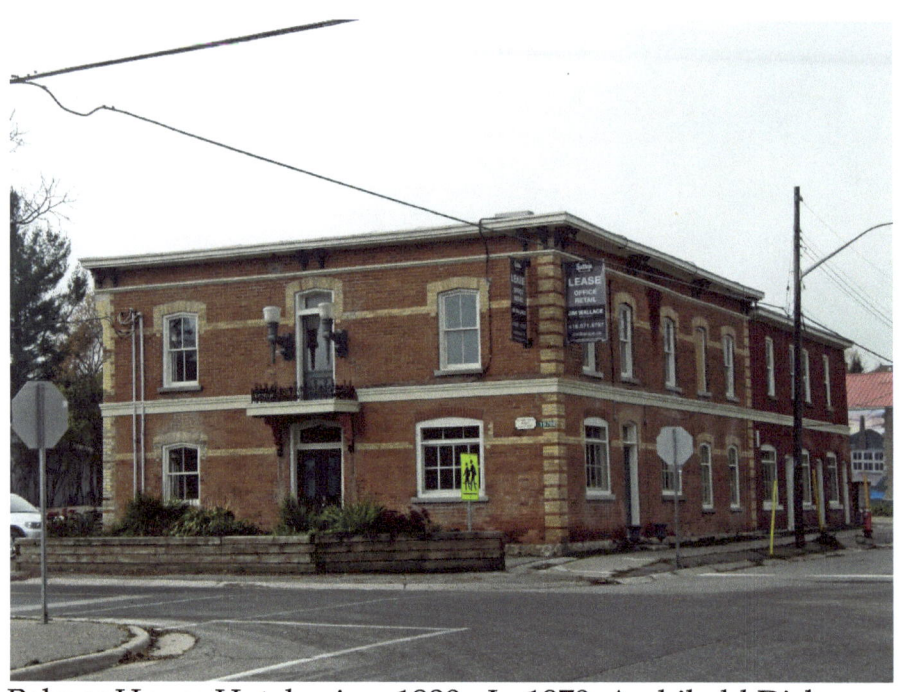

Palmer House Hotel - circa 1890 - In 1870, Archibald Dick built The Dixie House Hotel at the heart of what was Alton's commercial core. It was destroyed by fire in 1890 and replaced by this red brick Italianate style hotel with bracketed roofline parapet. The hotel is named after Joseph Palmer, owner from 1919 until his death in 1944; it closed its doors in the mid-1950s. The building has been extensively restored; the portico which has replaced the original two-level verandah across the front façade.

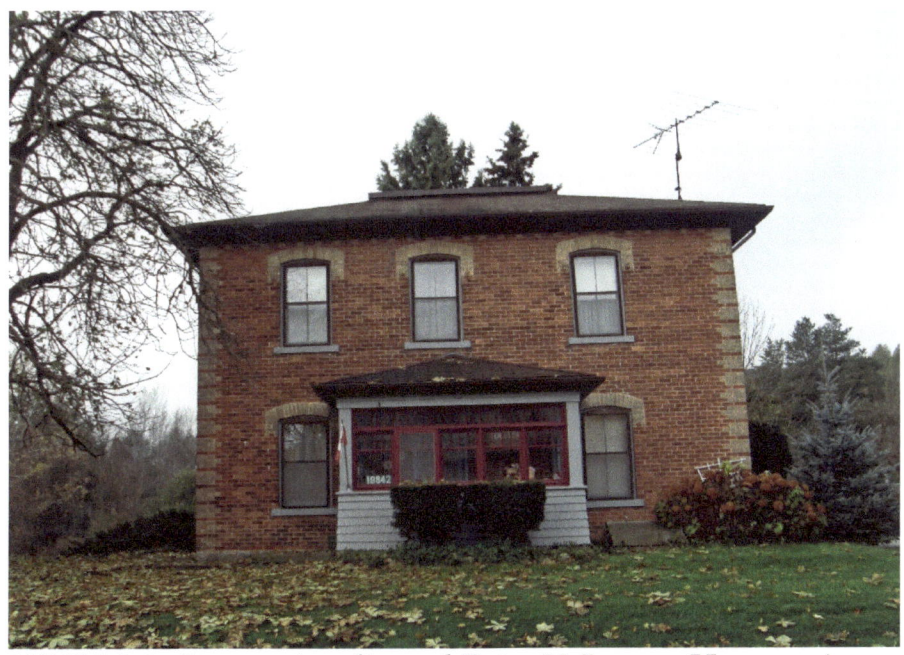

19842 Main Street - Amelia and Peter V. Lemon House - circa 1886 - This two-storey Italianate style, red brick house with yellow brick detail has ten rooms, an enclosed front porch and a truncated hip roof. Local farmer Peter Lemon and his wife Amelia bought the house in 1887. Amelia was Nancy and Nicholas Smith's daughter. After her death, Peter sold the property to Alexander Menzies in 1896.

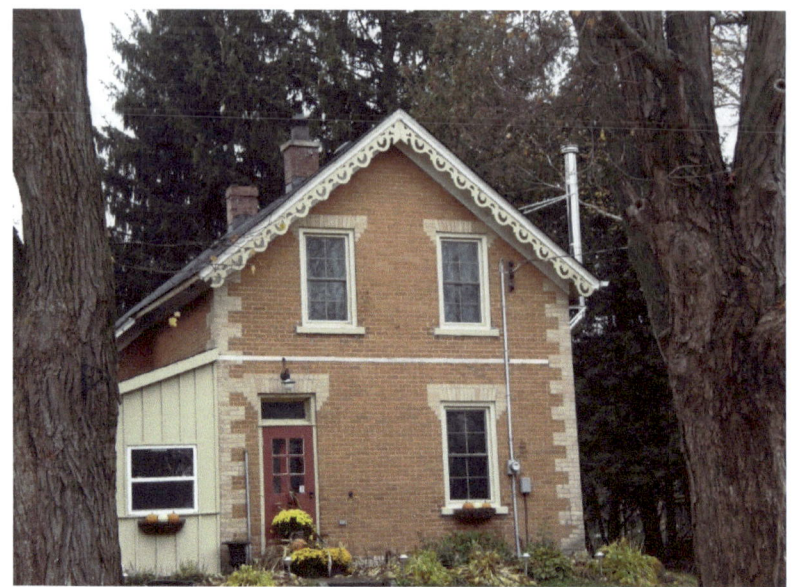

Gothic Revival – verge board trim, corner quoins, buff-coloured window lintels and sills

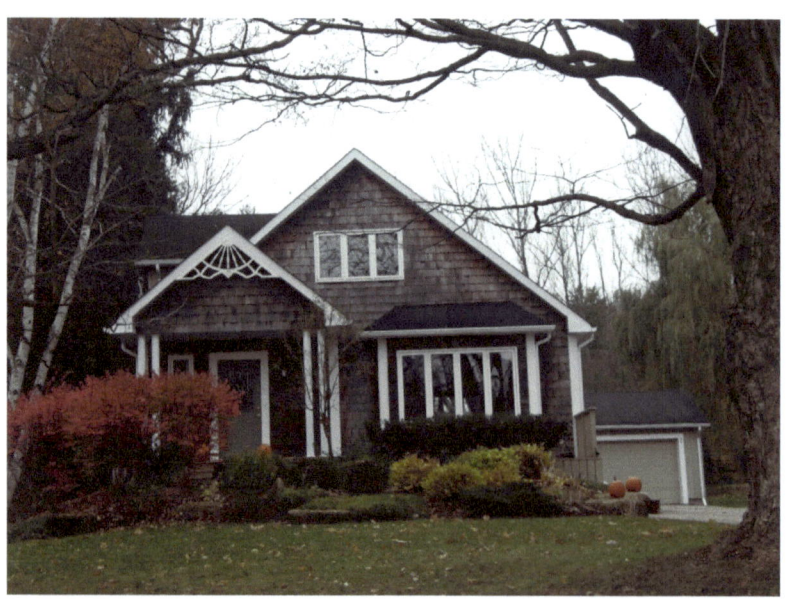

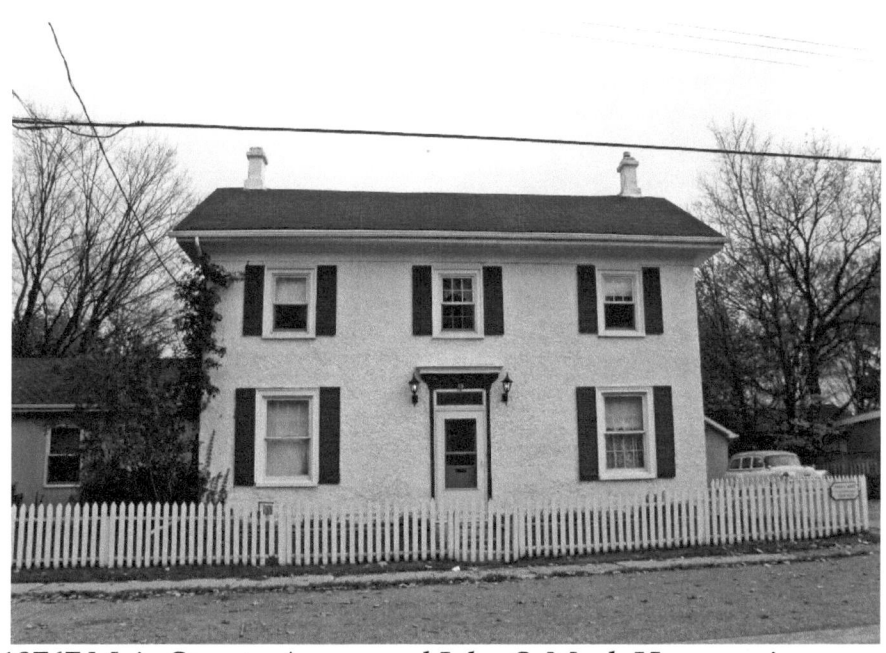

19767 Main Street - Agnes and John S. Meek House - circa 1853 - This two-storey Georgian style house with roughcast exterior and massive return eaves is one of Alton's earliest homes. John Meek, a merchant and hotel owner, was named Alton's first postmaster in 1854 and this house became the post office. After his death in 1866, Agnes Meek was appointed postmistress, followed in 1876 by their son James who served until 1883. The Meek's son Thomas owned the house until 1950.

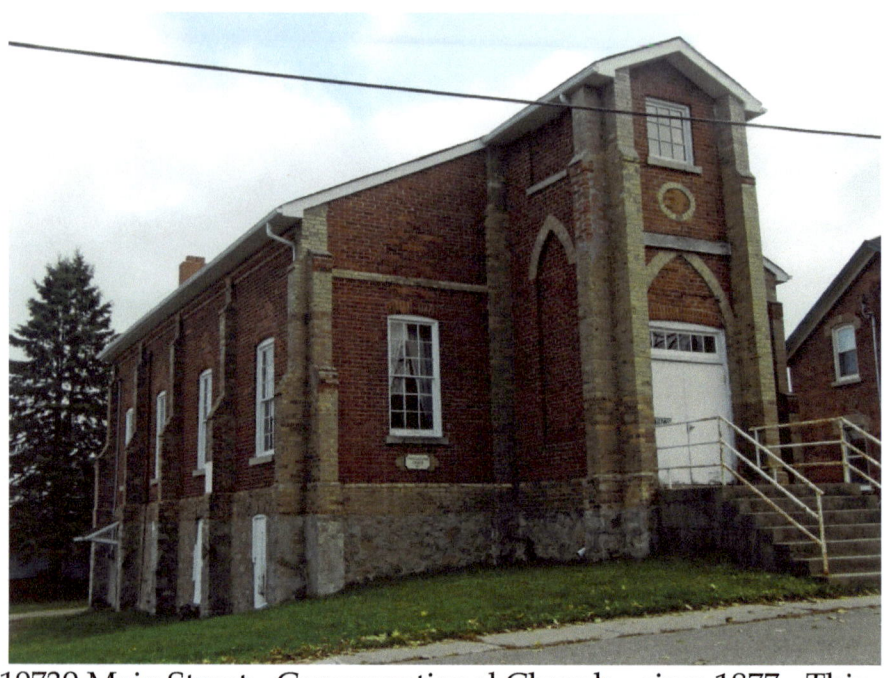

19739 Main Street - Congregational Church - circa 1877 - This Victorian Gothic style church is built on a fieldstone foundation with triple red brick construction, contrasting yellow brick detailing, front and side buttresses evenly interspaced with windows and a projecting front tower. The church congregation disbanded in 1910 and sold the building to Barber Carriage Company; during WW1 it stored raw wool for John M. Dods' mill. In 1918, the carriage company sold it to the Village as town hall. The basement was altered and from late 1930s to mid-1970s was Alton's fire hall. Later, the hall was leased as an antique store. In 2015, Paul Morin purchased the building and he has painstakingly restored it as his gallery.

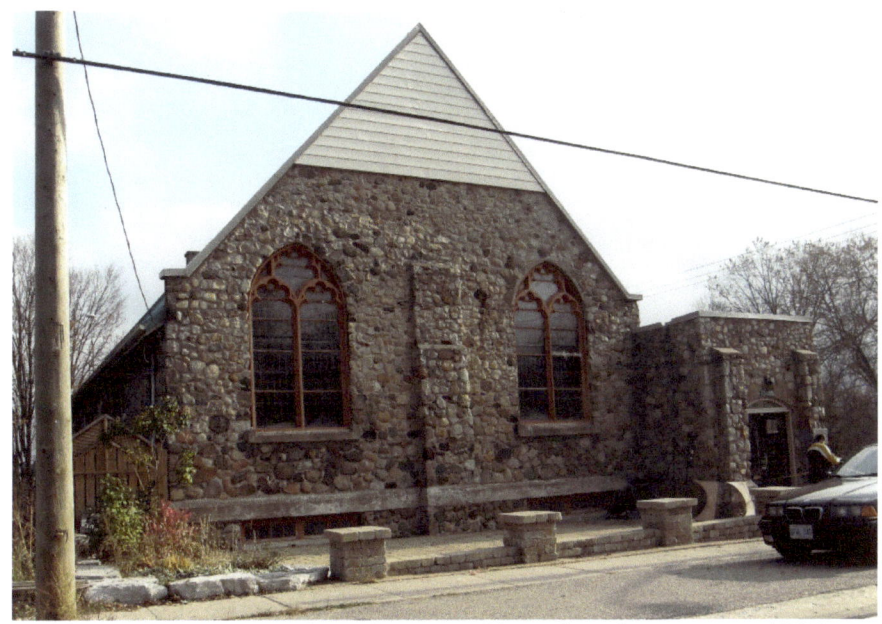

19695 Main Street - Alton Baptist Church - date stone 1926 - This rectangular fieldstone church was built with a steeply pitched gable roof and a buttressed entrance that resembles an adjoined gatehouse. The stones, harvested locally, have been randomly set. There are Gothic windows on the front façade and sides. The building served the Baptist congregation from 1926 until services ceased in 1984.

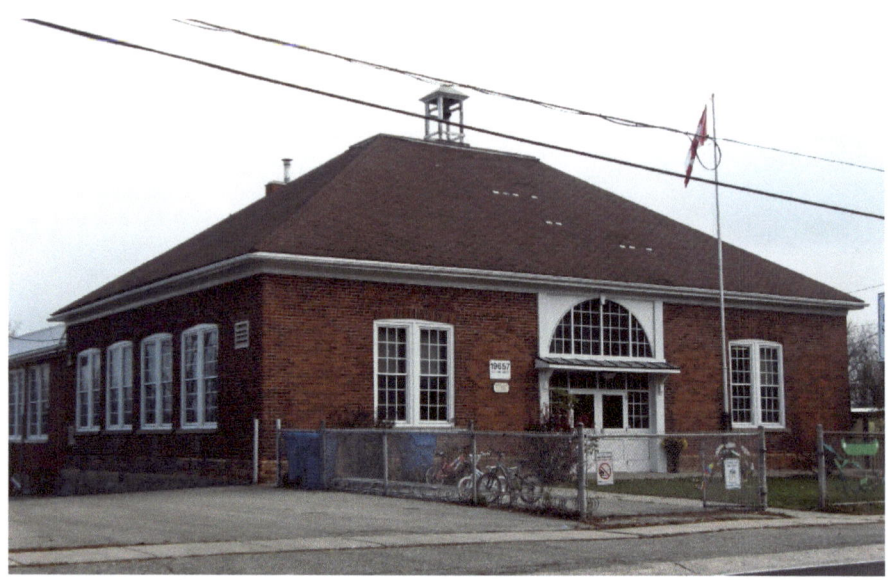

19657 Main Street - Alton Public School - 1875-1876 - The south classroom of this school was built in 1875 and in 1876 the school more than doubled its size with the addition of the north classroom and a third classroom with hall in the center. In 1928, a 'Continuation School' was added to the rear of the building. In later years, Grades 1 through 12 were taught here while Grade 13 students went to Orangeville by train. Until December 2014, this was the oldest school in use in Peel County, third oldest in Canada.

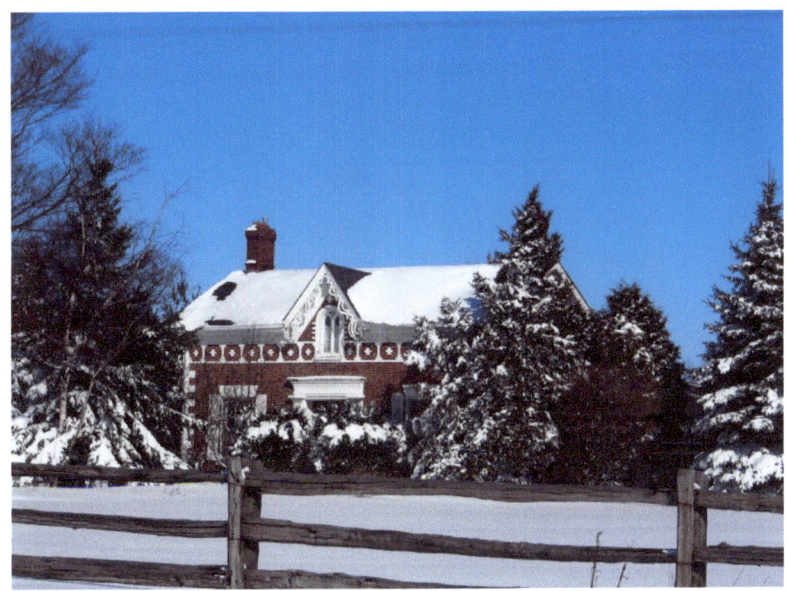

Gothic Revival – dichromatic brickwork, Vergeboard trim on gable

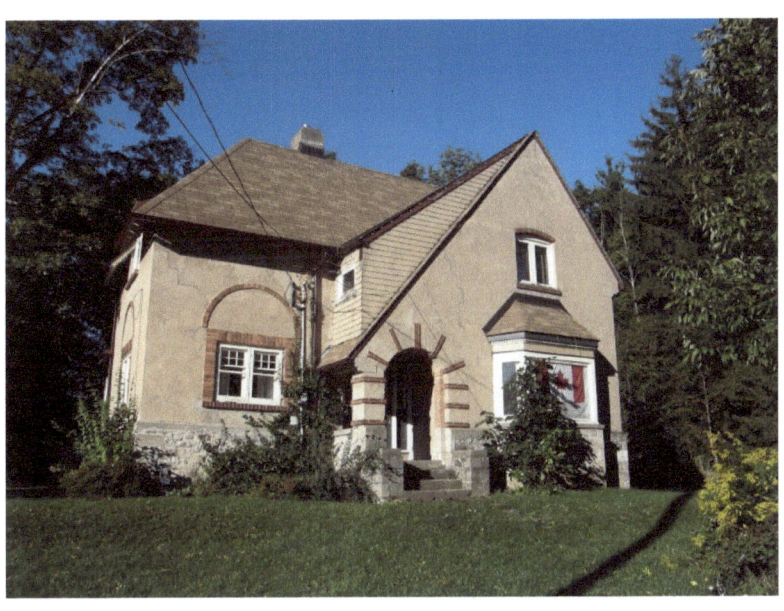

Caledon Village

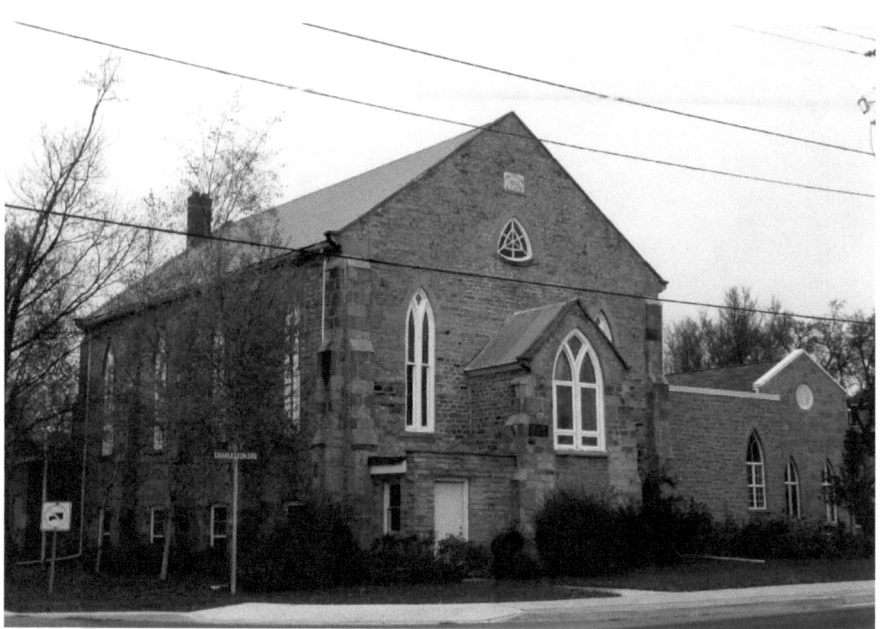

2976 Charleston Sideroad - Knox Presbyterian - 1873 datestone - Members of the Charleston Presbyterian congregation, formed in 1828, began construction of this stone church in 1870 to replace an earlier place of worship. Constructed using locally quarried stone with pews fashioned from local red pine, Knox Presbyterian was dedicated on January 1, 1873. Church union in 1925 resulted in the village's Methodist and Presbyterian congregations joining to become Knox United Church. Additions entailed a Sunday School extension in 1958 and a new main entrance in 1990.

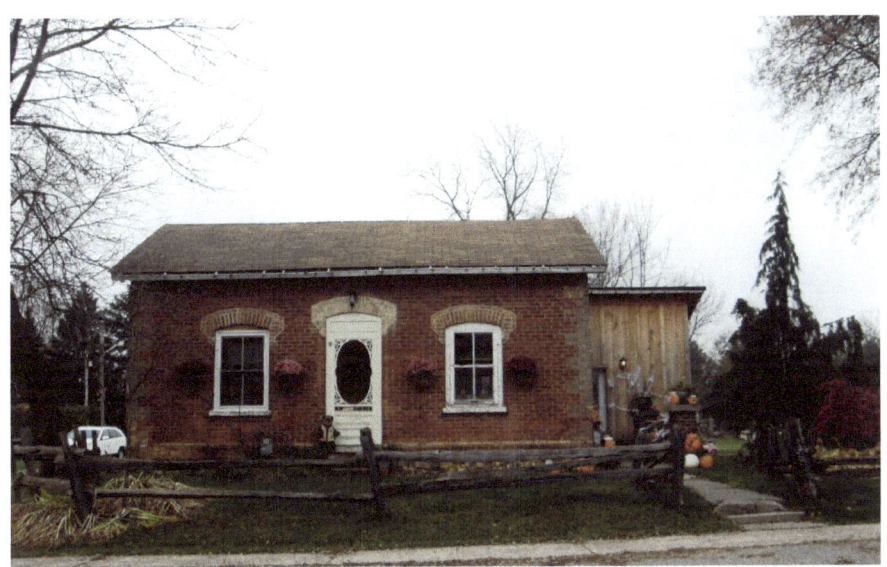

2 George Street – Neo-Classical Cottage – c. 1870s - This small cottage is locally known as Warnock's House, home of a prominent Caledon Township family. The exterior is clad with red brick with yellow brick patterning. This is an excellent example of Neo-Classical style with the center entry balanced by large windows on either side.

Gothic Revival - buff coloured banding and on corner quoins and voussoirs

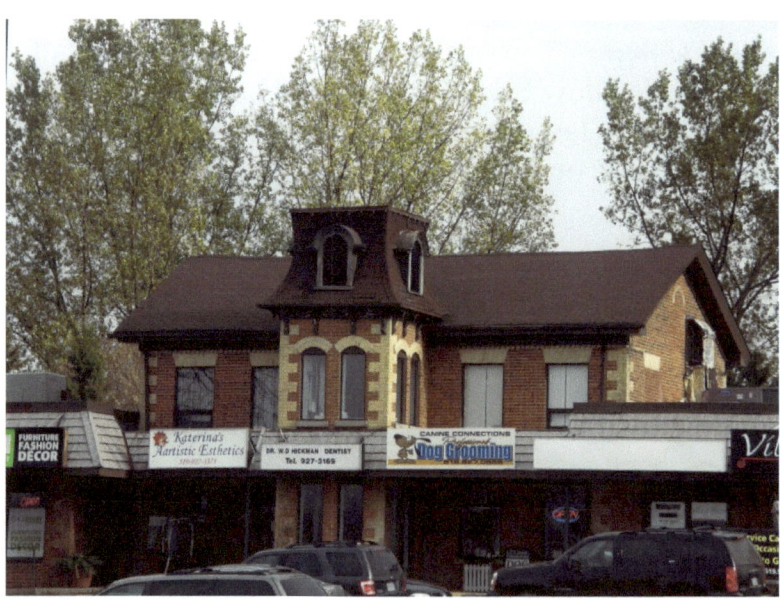

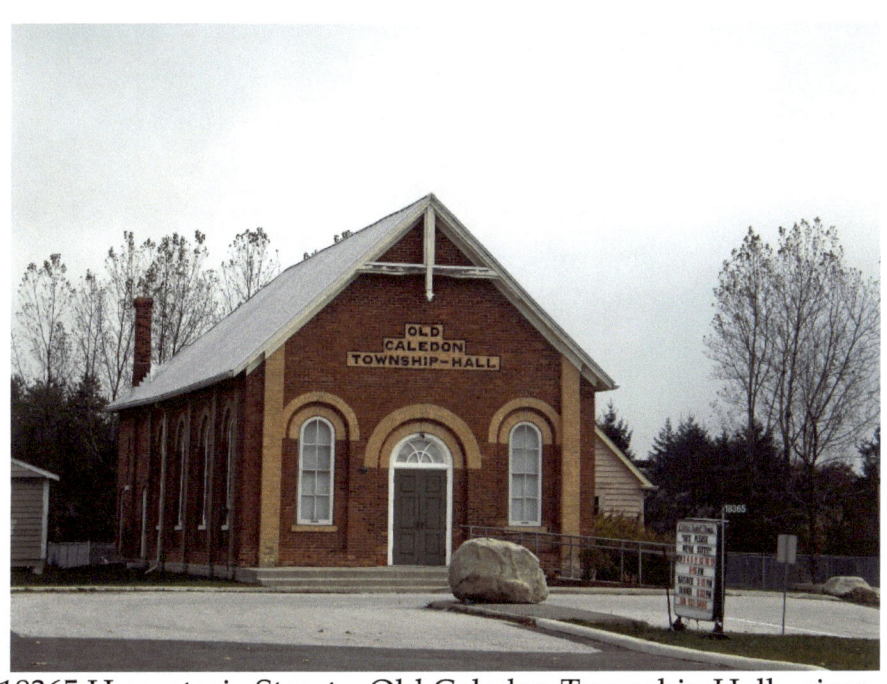

18365 Hurontario Street – Old Caledon Township Hall - circa A. D. 1875 - This building served as a court house, township hall, library and social center for 88 years. The rectangular, gable-roofed building, with its red brick construction, decorative buff brick detailing and rounded multi-pane windows, shows municipal architecture of the 1870s. When a new Township hall was constructed to the south of this building in 1963, the Town of Caledon agreed to lease this to the Caledon Townhall Players, an amateur theatre group. During the preparation for widening Highway 10, this building was moved east and south starting in July 2003 and a full basement was constructed.

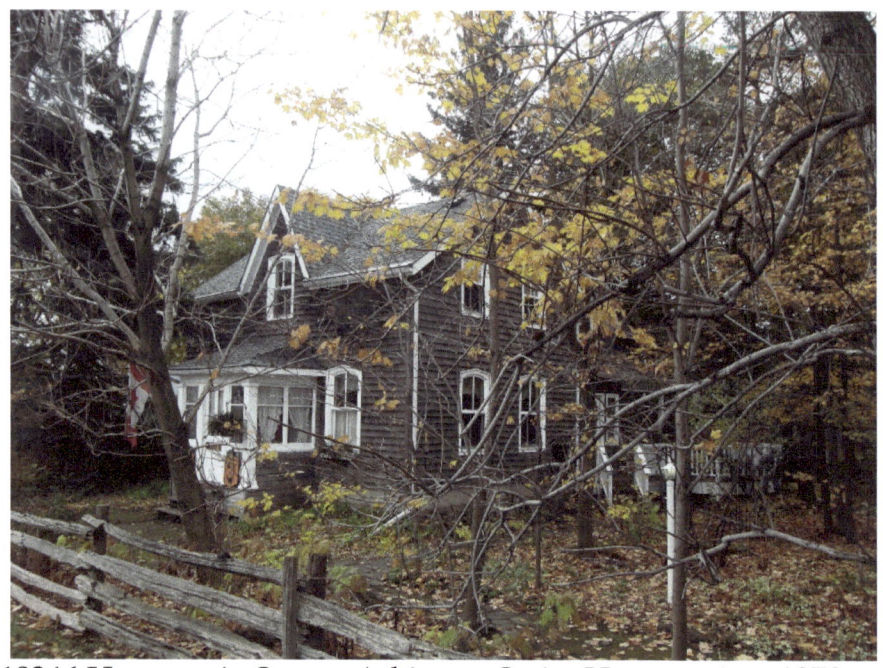

18346 Hurontario Street -Atkinson-Staite House - circa 1870 - This 1½ storey frame Ontario Cottage has a characteristic center entry, center gable with a Gothic window. With its board and batten exterior cladding, the style is locally referred to as Rural Gothic or Carpenter's Gothic. William and Verda Atkinson, known locally as "Billy A. and the herb lady, operated 'The Wee Gardens' here from 1945 to 1975. The Atkinsons grew their own plants, bottled the herbs, spices and condiments in the house and shipped product all over the world under their own label.

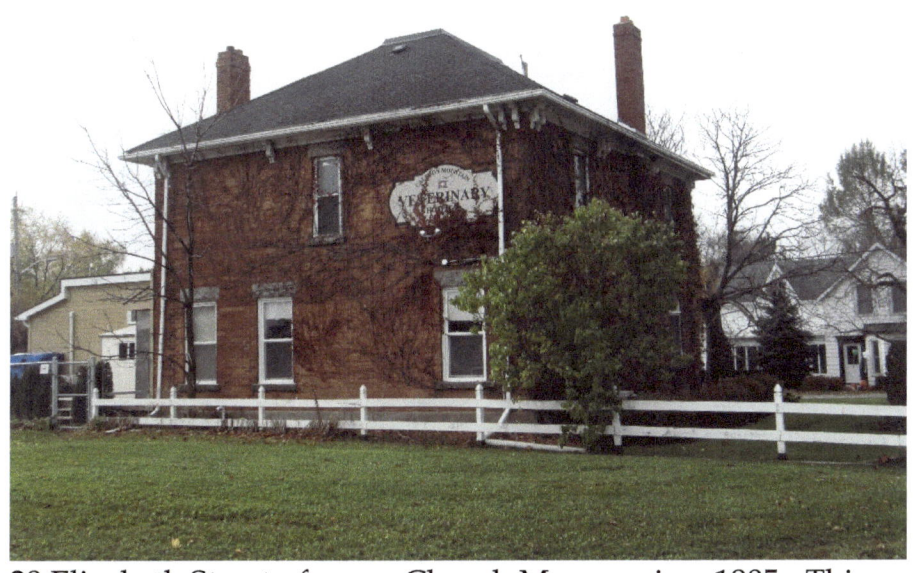

29 Elizabeth Street - former Church Manse - circa 1905 - This red brick house with its Romanesque style front entry has a pyramidal hip roof, rounded window arches and Italianate inspired paired brackets along the eaves. It replaced the original frame Presbyterian manse and after church union, served the ministers of Knox United Church until 1949, when the minister relocated to Alton. It is presently 'Caledon Mountain Veterinary Hospital'

Mono Centre

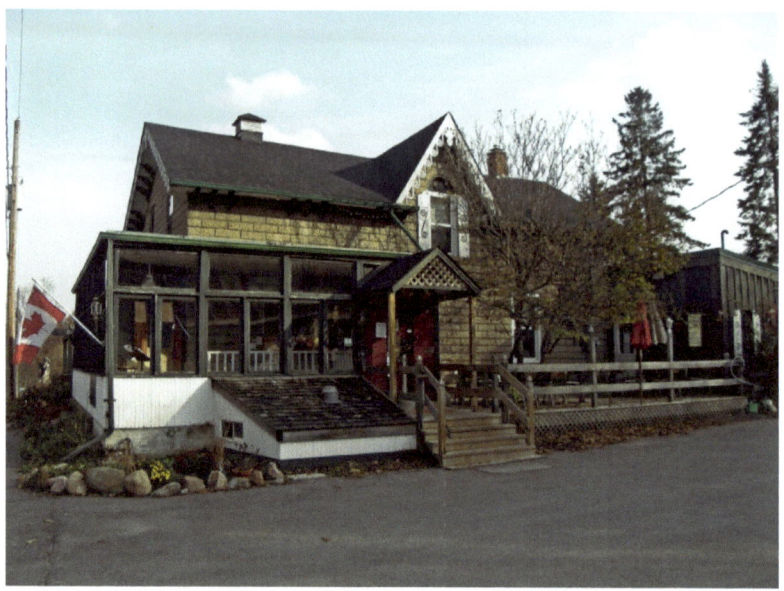

Mono Cliffs Inn was established in 1836 as a general store and post office serving the community for over one hundred years, closing in 1976. In 1987 it opened as a restaurant. It is situated on a scenic part of the Bruce Trail which runs through Mono Cliffs Provincial Park.

Gothic Revival style – verge board trim on gable, cornice brackets

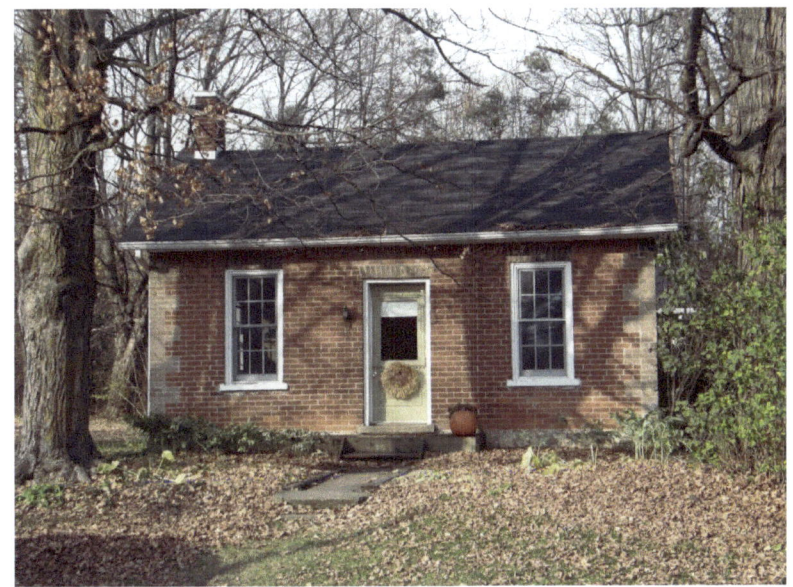

Regency Cottage – buff coloured quoins at the corners

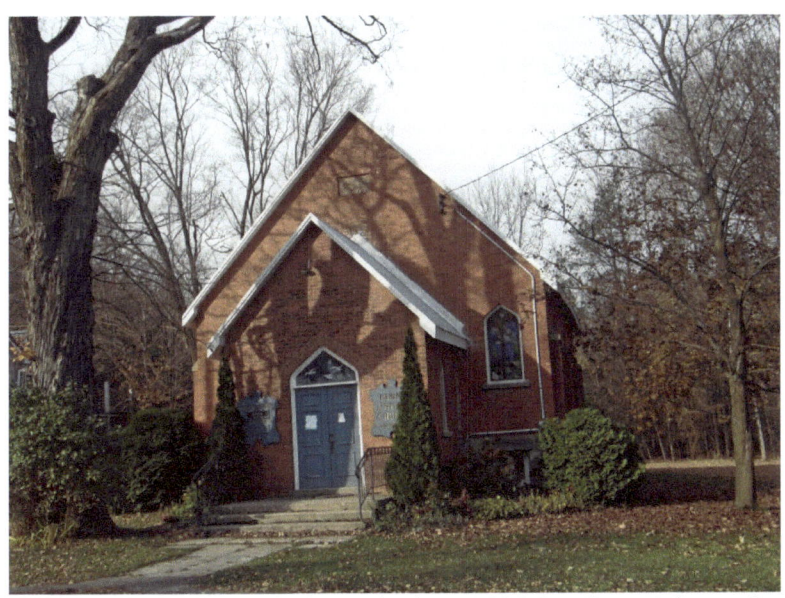

Burns United Church founded in 1837 by Scottish settlers

Architectural Terms

Brackets: a decorative or weight-bearing structural element which forms a right angle with one side against a wall and the other under a projecting surface such as an eave or roof. Example: 1581 Queen Street, Alton, Page 4	
Cornice: originally the wooden overhang of the roof. With the use of stone, brick, iron and steel, the cornice is any projecting shelf at the top of a ceiling or roof. They can be very decorative.	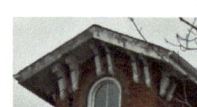
Dormer: (French for "sleep") a gable end window that pierces through the plane of a sloping roof surface to create usable space in the top floor or attic of a building by adding headroom. Example: 1398 Queen Street, Alton, Page 23	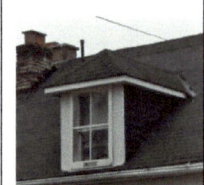
Finial: ornament added to the top of a gable, pinnacle, canopy or spire – a Gothic element. Example: Alton, Page 26	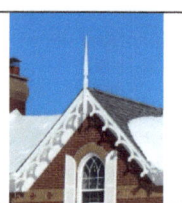

Gable: the triangular portion of a wall between the edges of a sloping roof. Example: 1581 Queen Street, Alton, Page 4	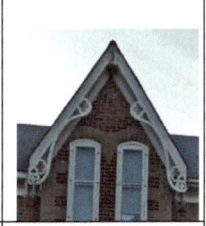
Hipped Roof: a roof where all sides slope downwards to the walls with no gables. Example: Caledon Mountain Veterinary Hospital – 29 Elizabeth Street, Caledon Village, Page 44	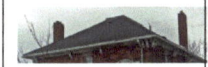
Verge boards: also called bargeboards (gingerbread) – hang from the projecting end of a roof and are often elaborately carved and ornamented. Example: Mono Cliffs Inn, Page 45	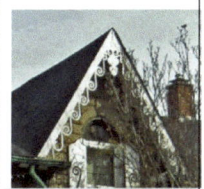
Voussoir: a wedge-shaped element used in building an arch. Example: Caledon Village, Page 41	

Alton's Building Styles

Edwardian, 1900-1930 – This style bridges the ornate and elaborate styles of the Victorian era and the simplified styles of the 20th century. Balanced facades, simple roof lines, dormer windows, large front porches, and smooth brick surfaces are its characteristics. Example: 1417 Queen Street West, Alton, Page 15	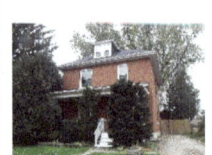
Georgian, before 1860 – This style began with the British King Georges in the 18th century. These buildings have balanced facades around a central door, medium-pitched gable roofs, and small paned windows. Example: 19767 Main Street, Alton, Page 34	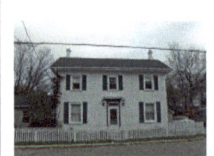
Gothic Revival, 1830-1890 – These decorative buildings have sharply-pitched gables with highly detailed vergeboards, pointed-arch window openings, and dichromatic brickwork. It is a common style in Ontario. Example: 1581 Queen Street, Alton, Page 4	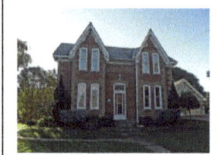
Italianate, 1850-1900 – It has wide-bracketed eaves, belvederes, wrap-around verandahs. Example: Mansion on the hill, Alton, Page 25	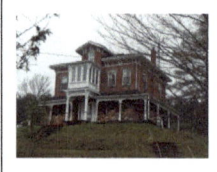

Neo-Classical, 1810-1850 – This style was a direct result of the War of 1812. Many Upper Canadians returning from the war with the United States were second or third generation Loyalists who had inherited land and means from their forefathers. Once the conflict had passed, they had the money and the time to expand their holdings and indulge their architectural whims. Both residential and commercial buildings were constructed on the traditional Georgian plan, but they had a new gaiety and light-heartedness. Detailing became more refined, delicate, and elegant. Example: 1414 Queen Street West, Alton, Page 16	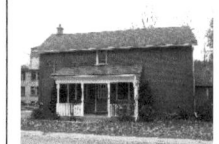
Ontario Cottage - one or one-and-a-half story buildings with a cottage or hip roof. The cottage roof is an equal hip roof where each hip extends to a point in the center of the roof. The hip roof has a long hip in the center. The Ontario Cottage is the vernacular design of the Regency Cottage which generally has a more ornate doorway and a partial or full verandah surrounding it. The roof can have a dormer, a belvedere, and generally two chimneys. Example: 1465 Queen Street West, Alton, Page 9	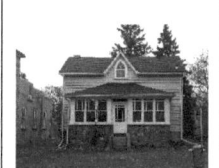
Romanesque Revival, 1880-1910 – This style hearkens back to medieval architecture of the 11th and 12th centuries with a heavy appearance, blocky towers and rounded arches. Example: 1401 Queen Street West, Alton, Page 22	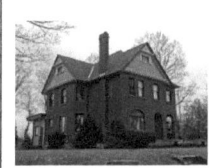

Other Books by Barbara Raue

Coins of Gold
Arrows, Indians and Love
The Life and Times of Barbara
The Cromwell Family Book
Laura Secord Discovered
Daddy Where Are You?

Montana Series
Book 1: Montana Dream
Book 2: Life on the Montana Frontier
Book 3: Montana to Boston and Back
Book 4: Montana Sons Go to War
Book 5: Montana Sons Return from War

© 2019 by Barbara Raue - All the photos in this book have been taken with my cameras. I own the rights to them.

www.ingramcontent.com/pod-product-compliance
Lightning Source LLC
Chambersburg PA
CBHW040917180526
45159CB00002BA/507